DesignOriginals

Creative Coloring
Patterns *of* Nature

Valentina Harper

DESIGN ORIGINALS
an Imprint of Fox Chapel Publishing
www.d-originals.com

Basic Color Ideas

In order to truly enjoy this coloring book, you must remember that there is no wrong way—or right way—to paint or use color. My drawings are created precisely so that you can enjoy the process no matter what method you choose to use to color them!

The most important thing to keep in mind is that each illustration was made to be enjoyed as you are coloring, to give you a period of relaxation and fun at the same time. Each picture is filled with details and forms that you can choose to color in many different ways. I value each person's individual creative process, so I want you to play and have fun with all of your favorite color combinations.

As you color, you can look at each illustration as a whole, or you can color each part as a separate piece that, when brought together, makes the image complete. That is why it is up to you to choose your own process, take your time, and, above all, enjoy your own way of doing things.

To the right are a few examples of ways that you can color each drawing.

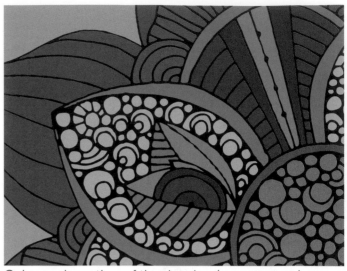

Color each section of the drawing (every general area, not every tiny shape) in one single color.

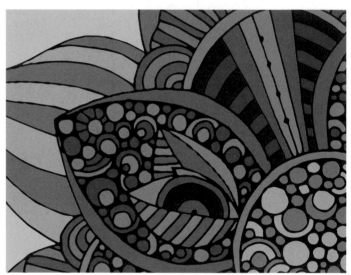

Within each section, color each detail (small shape) in alternating colors.

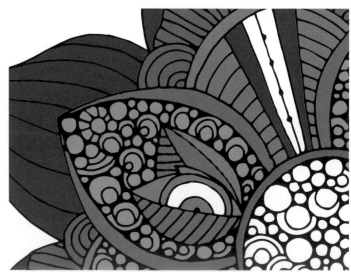

Leave some areas white to add a sense of space and lightness to the illustration.

Basic Color Tips

As an artist, I love to mix techniques, colors, and different mediums when it comes time to add color to my works of art. And when it comes to colors, the brighter the better! I feel that with color, illustrations take on a life of their own.

Remember: when it comes to painting and coloring, there are no rules. The most fun part is to play with color, relax, and enjoy the process and the beautiful finished result.

Feel free to mix and match colors and tones. Work your way from primary colors to secondary colors to tertiary colors, combining different tones to create all kinds of different effects. If you aren't familiar with color theory, below is a quick, easy guide to the basic colors and combinations you will be able to create.

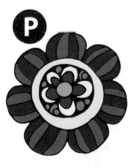

Primary colors: These are the colors that cannot be obtained by mixing any other colors; they are yellow, blue, and red.

Secondary colors: These colors are obtained by mixing two primary colors in equal parts; they are green, purple, and orange.

Tertiary colors: These colors are obtained by mixing one primary color and one secondary color

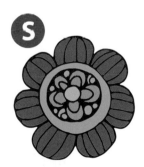

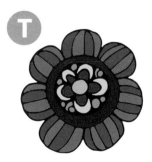

Don't be afraid of mixing colors and creating your own palettes. Play with colors—the possibilities are endless!

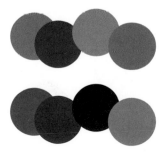

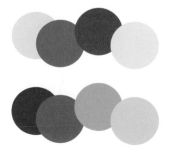

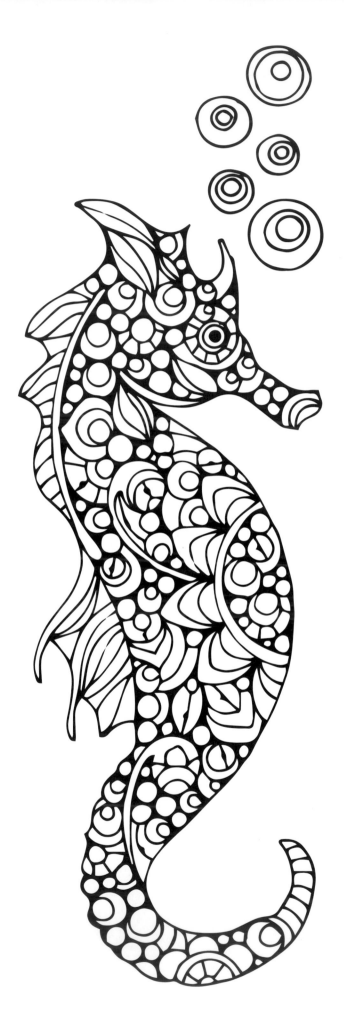

Color Inspiration

On the following eight pages, you'll see fully colored samples of my illustrations in this book, as interpreted by one talented artist and author, Marie Browning. I was delighted to invite Marie to color my work, and she used many different mediums to do so, all listed below each image. Take a look at how Marie decided to color the doodles, and find some inspiration for your own coloring! After the colored samples, the thirty delightful drawings just waiting for your color begin. Remember the tips I showed you earlier, think of the color inspiration you've seen, and choose your favorite medium to get started, whether it's pencil, marker, watercolor, or something else. Your time to color begins now, and only ends when you run out of pages! Have fun!

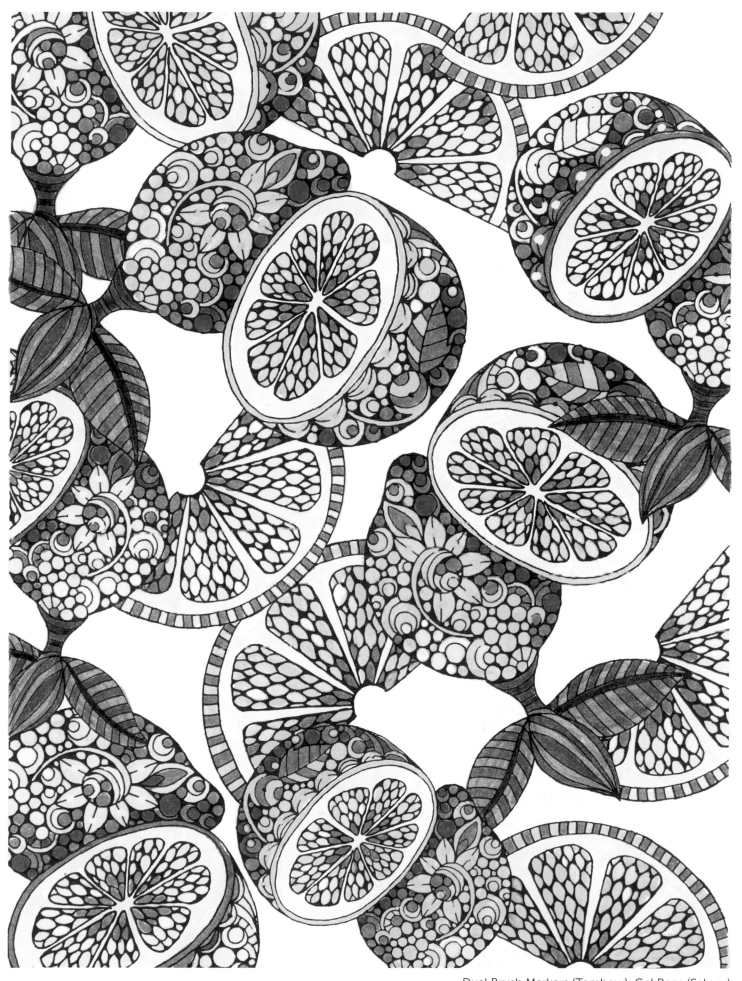

Dual Brush Markers (Tombow), Gel Pens (Sakura).
Vivid citrus tones. Color by Marie Browning.

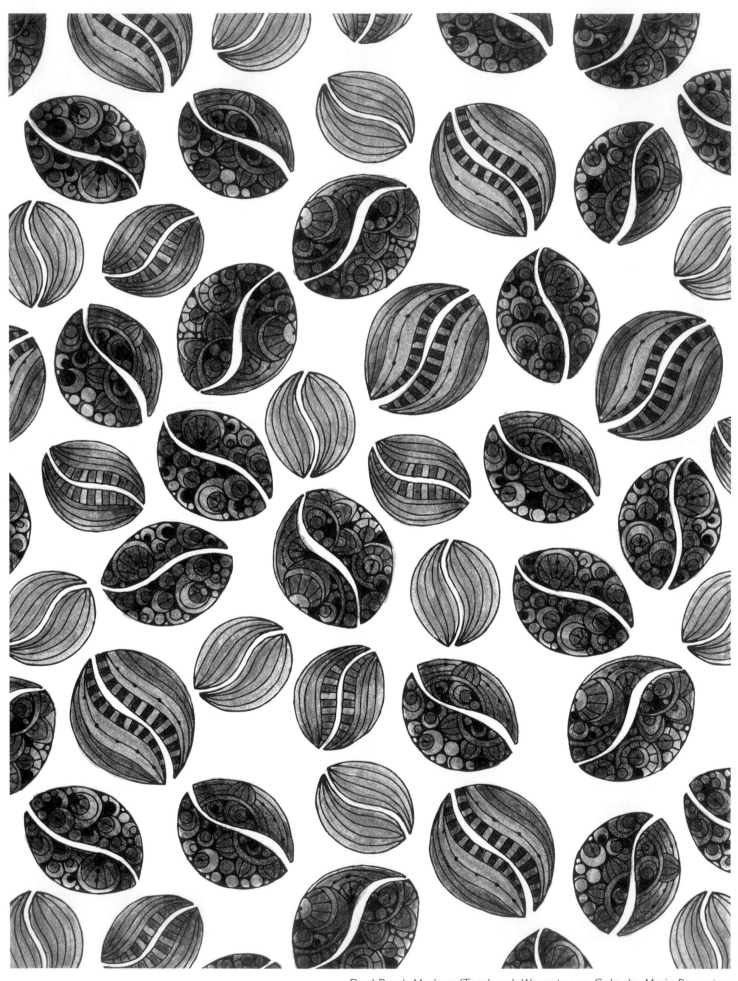

Dual Brush Markers (Tombow). Warm tones. Color by Marie Browning.

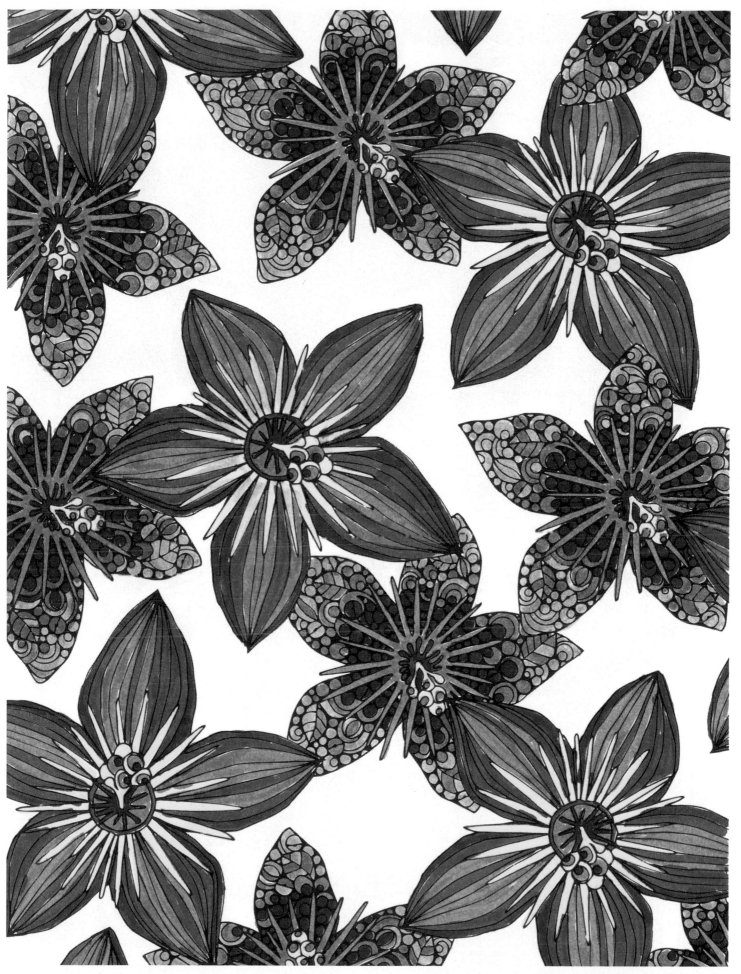

Dual Brush Markers (Tombow). Bright analogous tones.
Color by Marie Browning

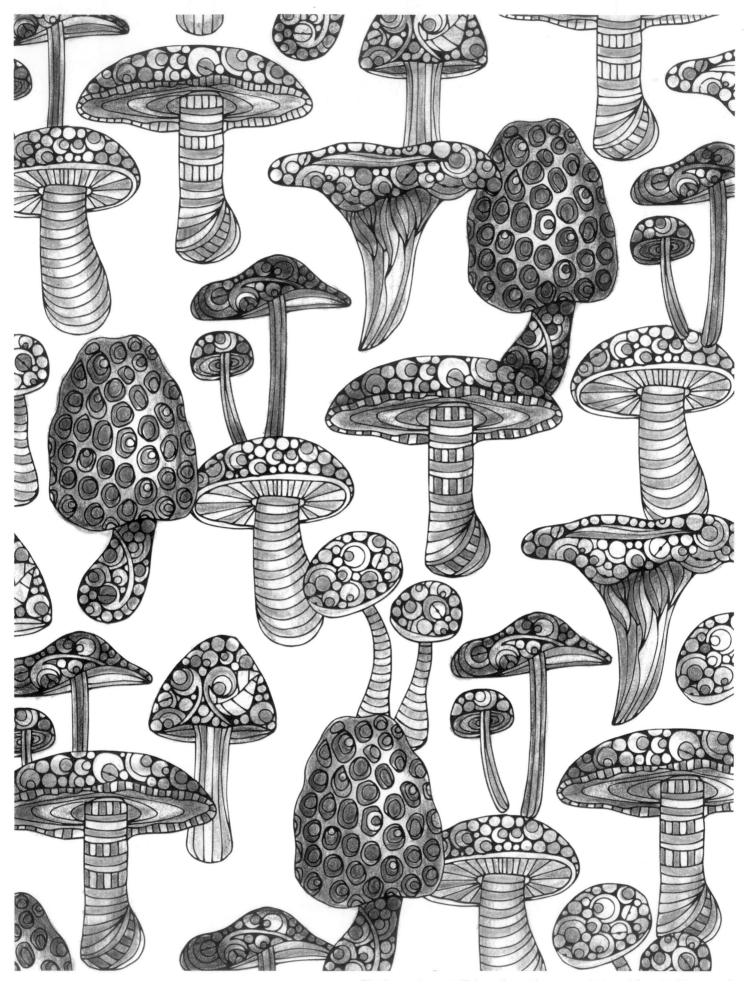

Pitt Pastel Pencils (Faber-Castell), Irojiten Colored Pencils (Tombow).
Muted pale tones. Color by Marie Browning.

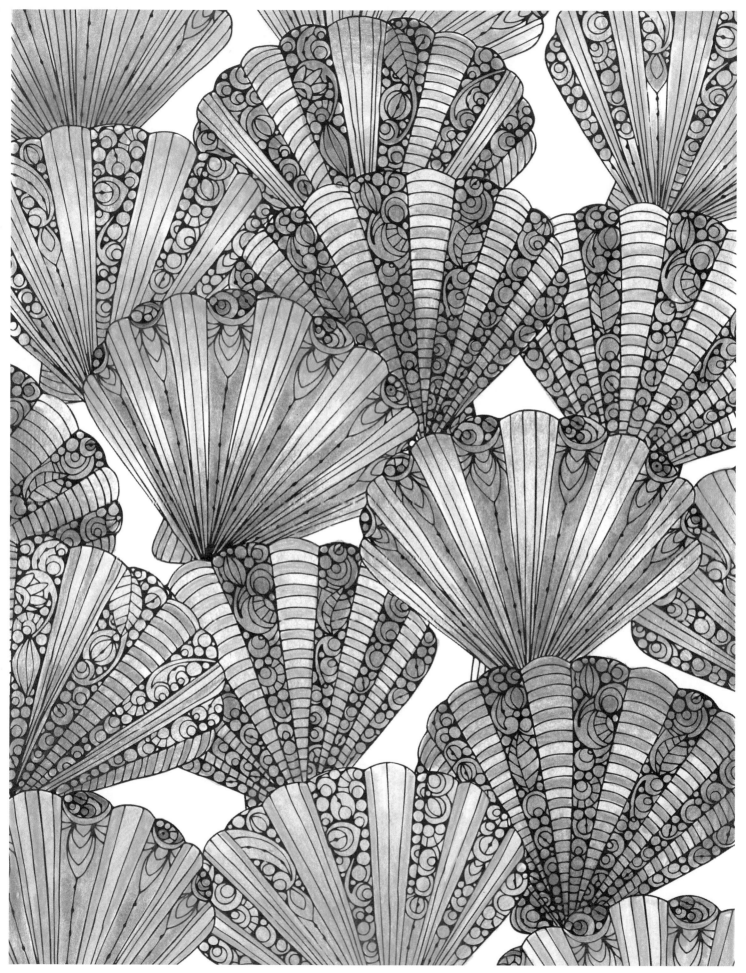

Irojiten Colored Pencils (Tombow). Pale tones.
Color by Marie Browning.

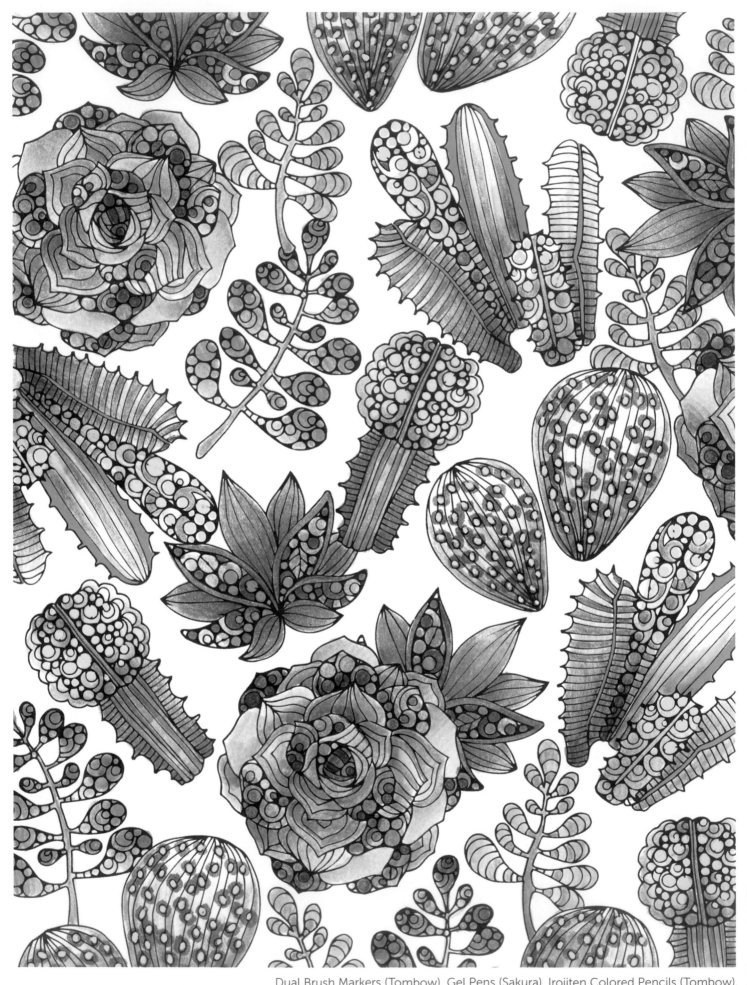

Dual Brush Markers (Tombow), Gel Pens (Sakura), Irojiten Colored Pencils (Tombow).
Monochromatic tones. Color by Marie Browning.

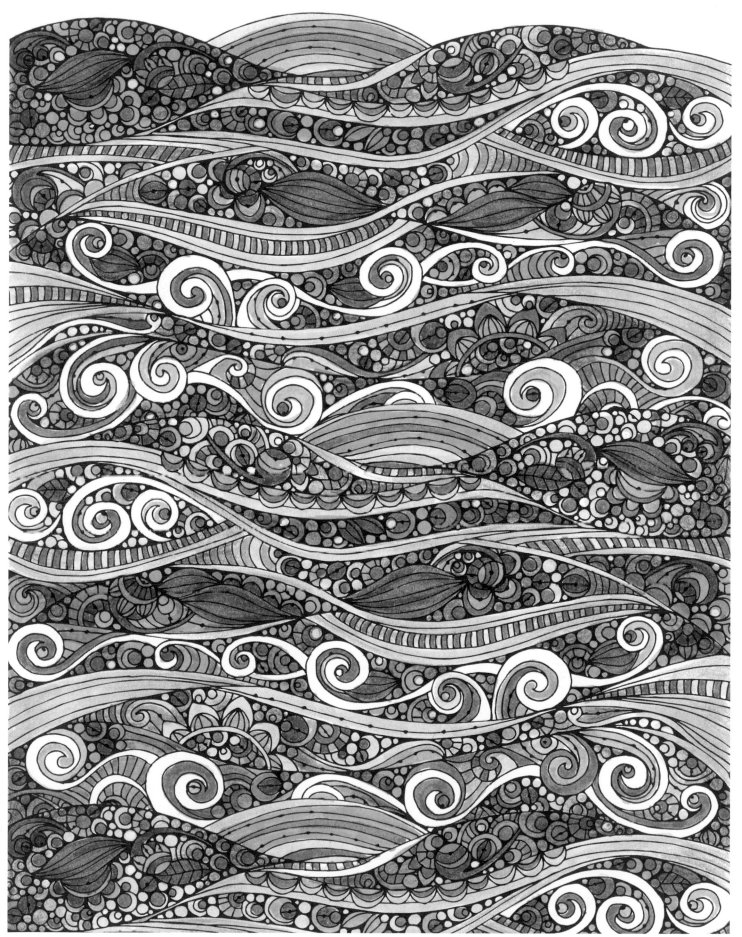

Dual Brush Markers (Tombow). Cool tones.
Color by Marie Browning.

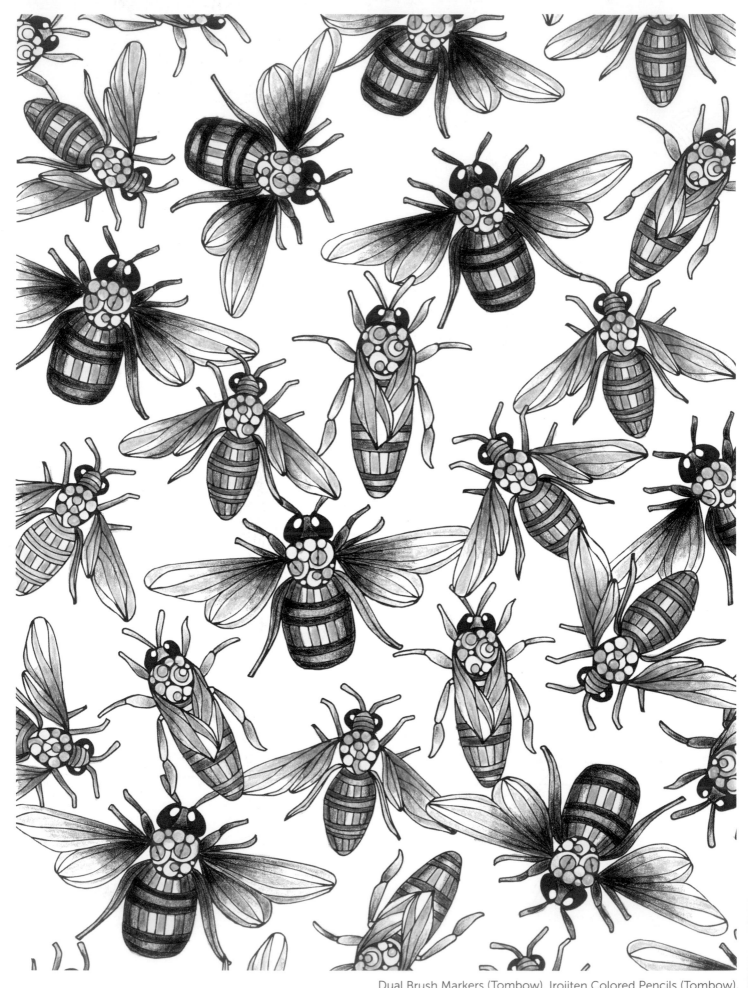

Dual Brush Markers (Tombow), Irojiten Colored Pencils (Tombow).
Jewel tones. Color by Marie Browning.

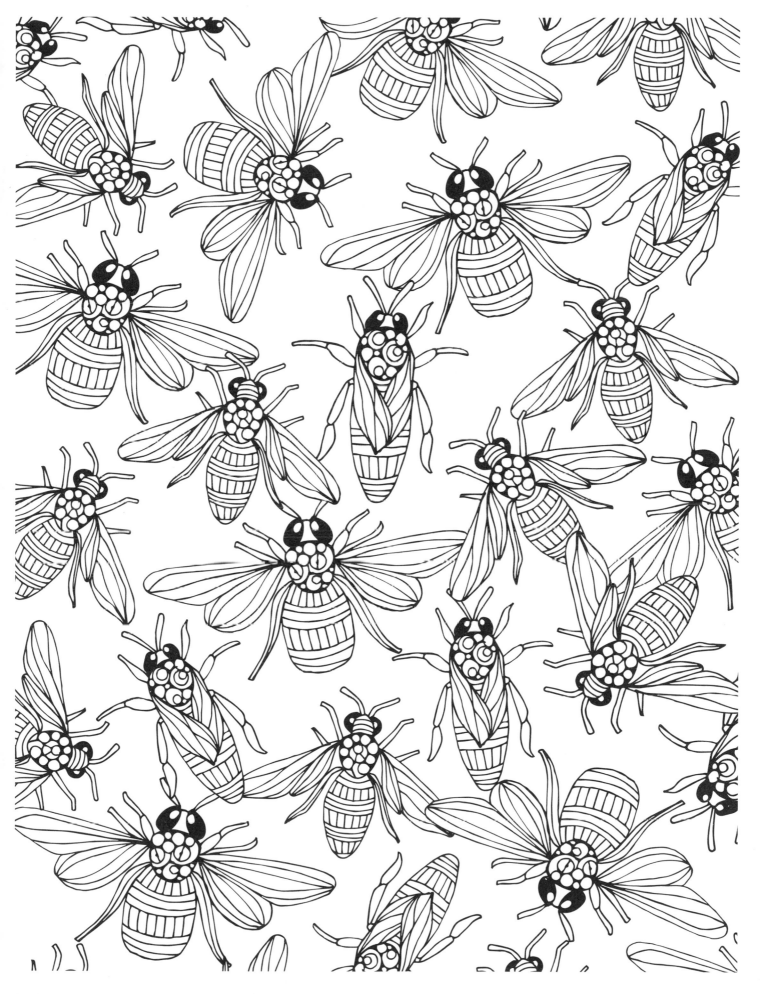

Float like a butterfly, sting like a bee.

—Mohammad Ali

Bees

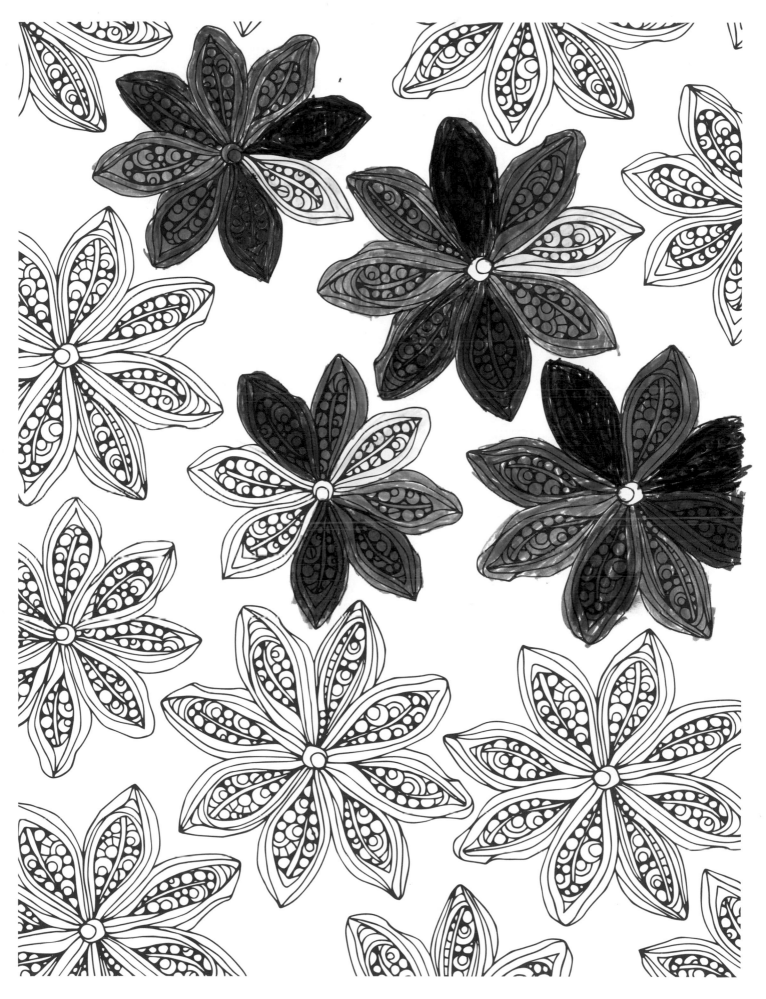

Don't go through life, grow through life.

—Eric Butterworth

Anise

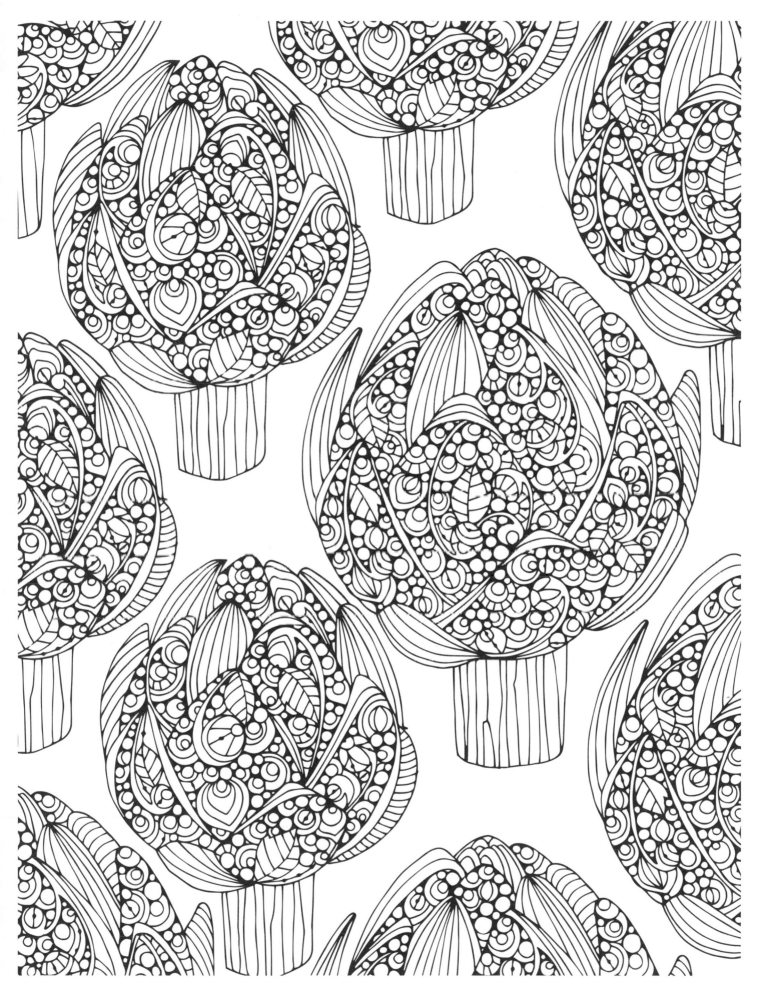

People who love to eat
are always the best people.

—Julia Child

Artichokes

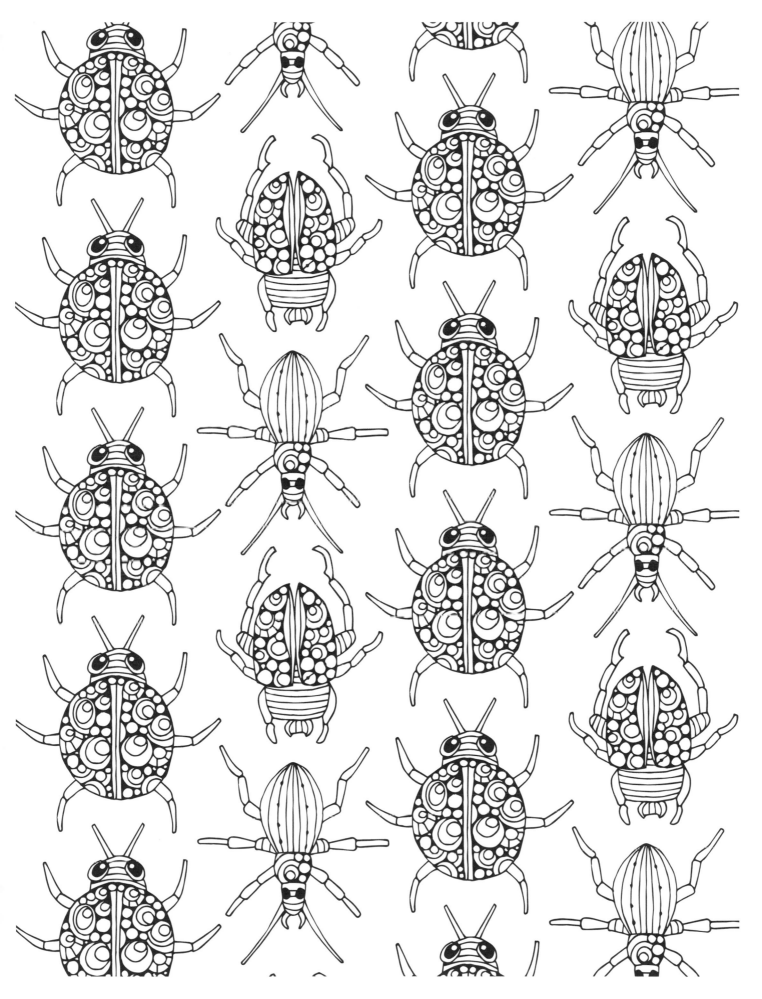

Together, even the smallest can
achieve the greatest goal.

—A Bug's Life

Beetles

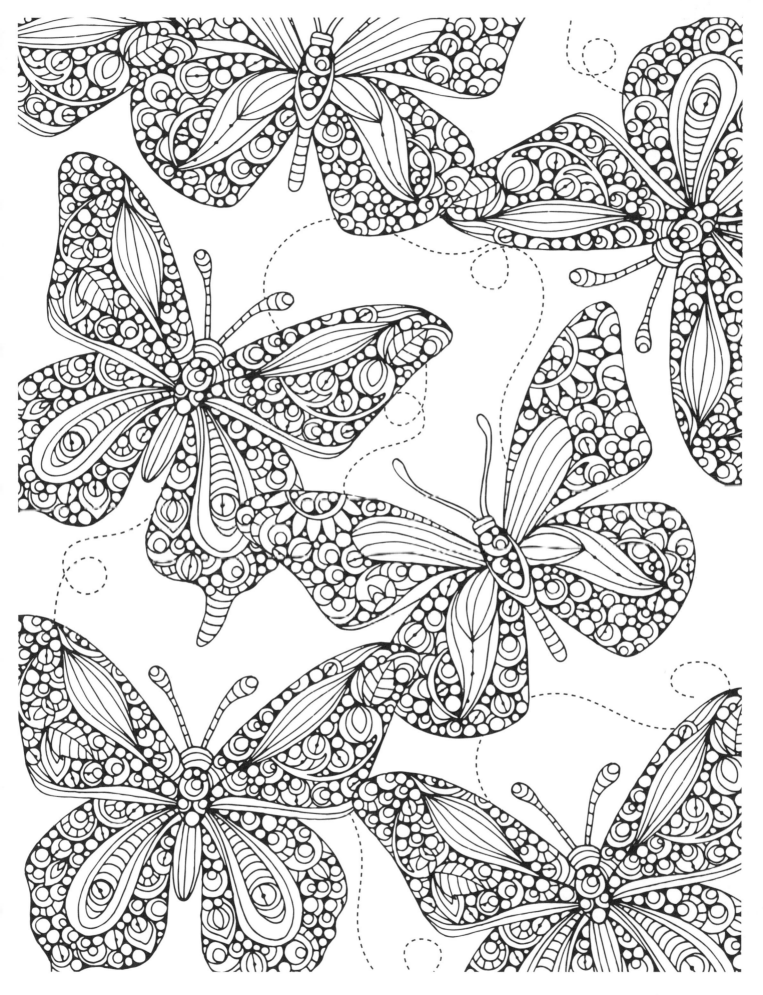

If nothing ever changed,
there would be no butterflies.

—Unknown

Butterflies

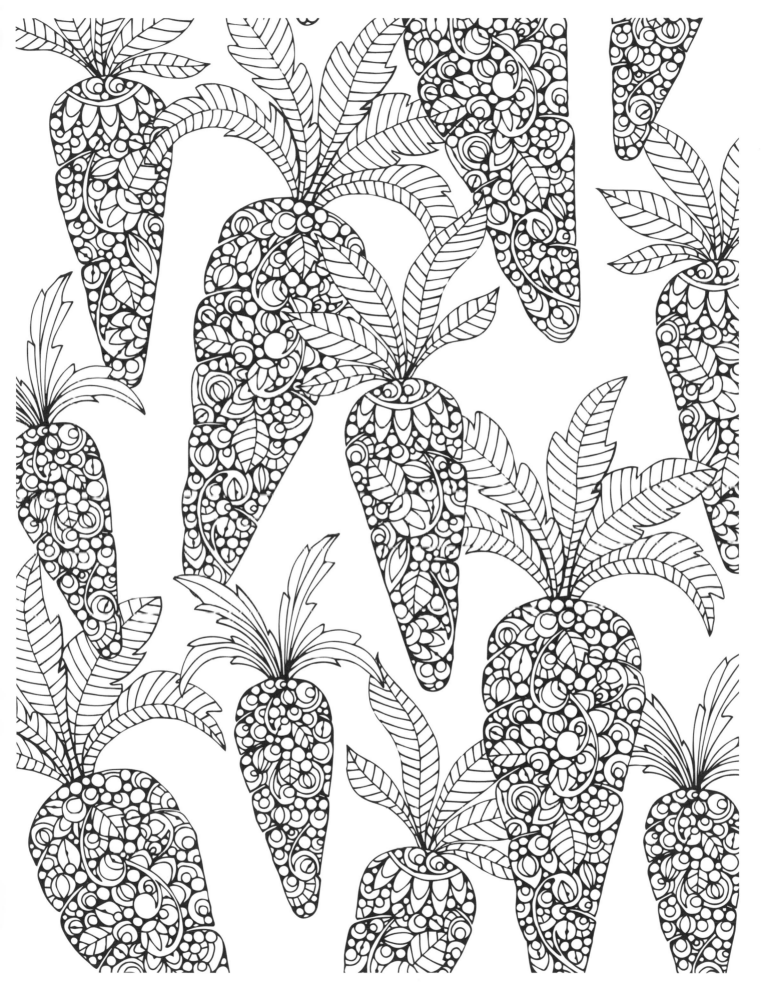

Vegetables are a must on a diet. I suggest
carrot cake, zucchini bread, and pumpkin pie.

—Jim Davis, *Garfield*

Carrots

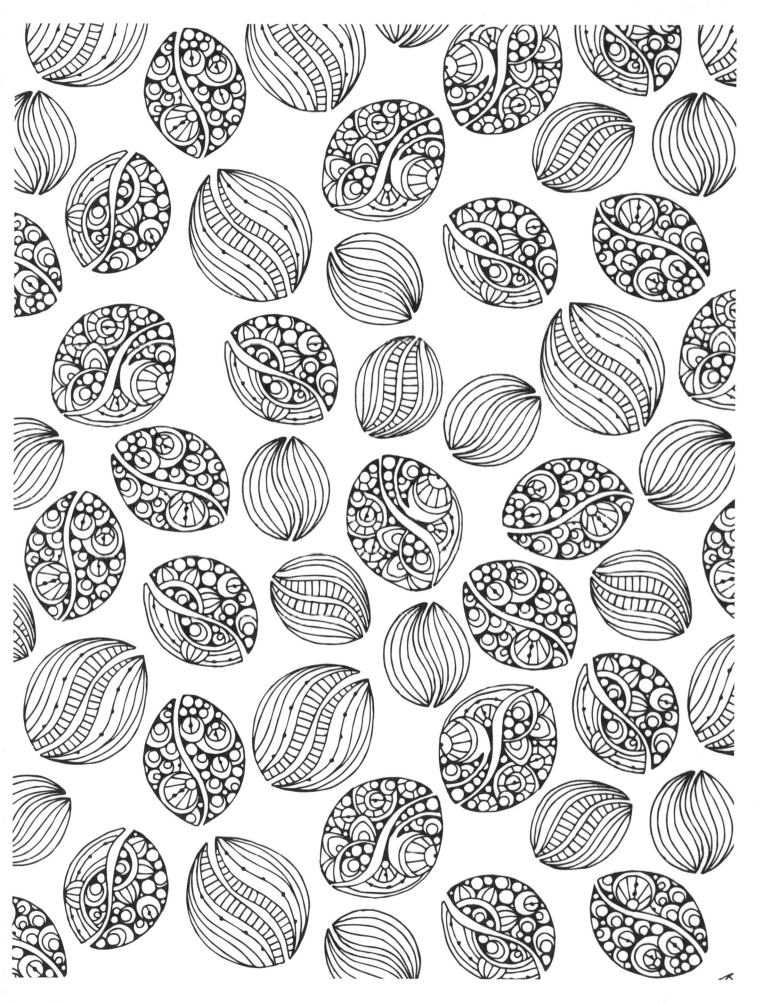

Love is in the air... and it smells like coffee.

—Unknown

Coffee

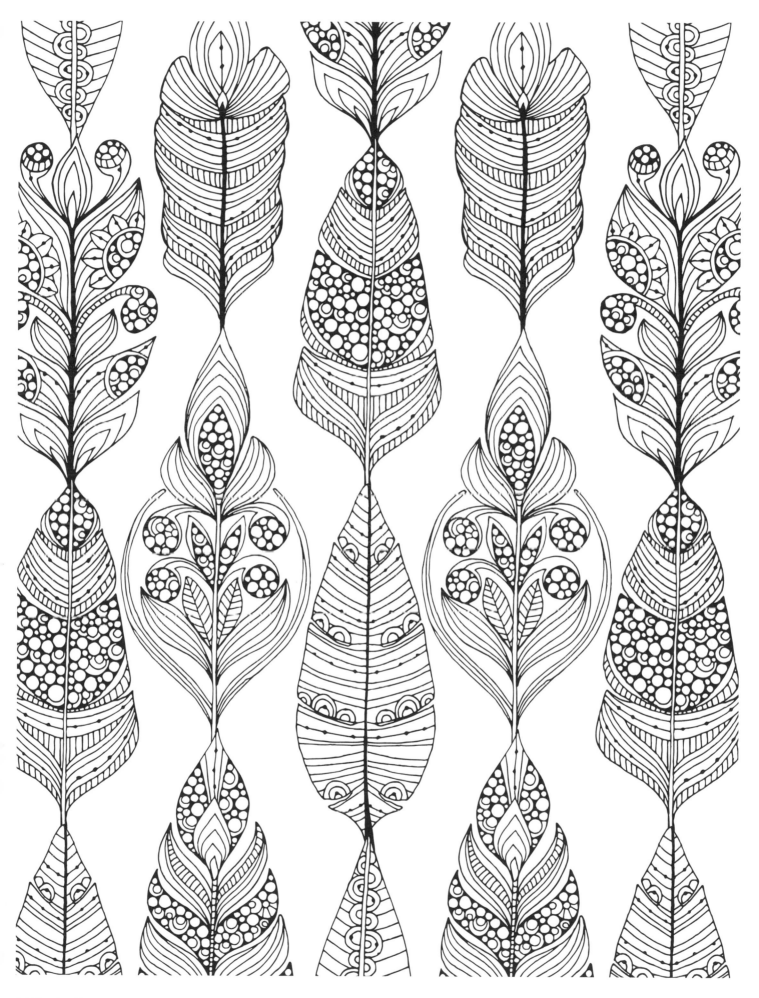

A bird is three things:
Feathers, flight and song,
And feathers are the least of these.

—Marjorie Allen Seiffert, *The Shining Bird*

Feathers

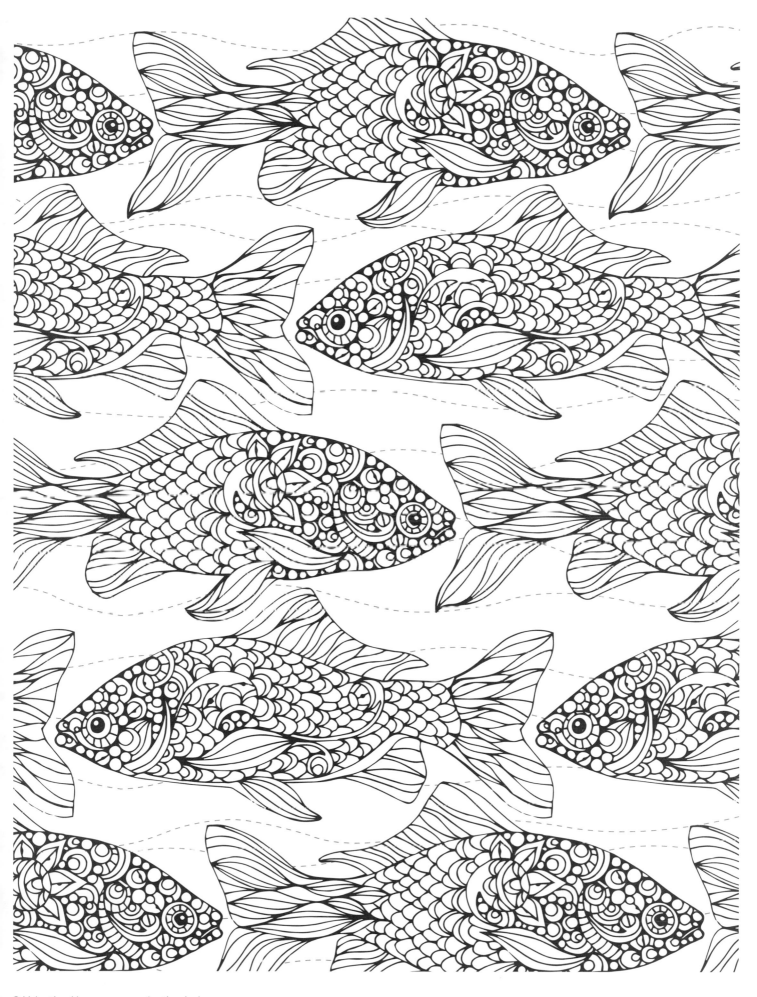

When life gets you down, do you
wanna know what you've gotta do?
Just keep swimming.

—Dory, *Finding Nemo*

Fish

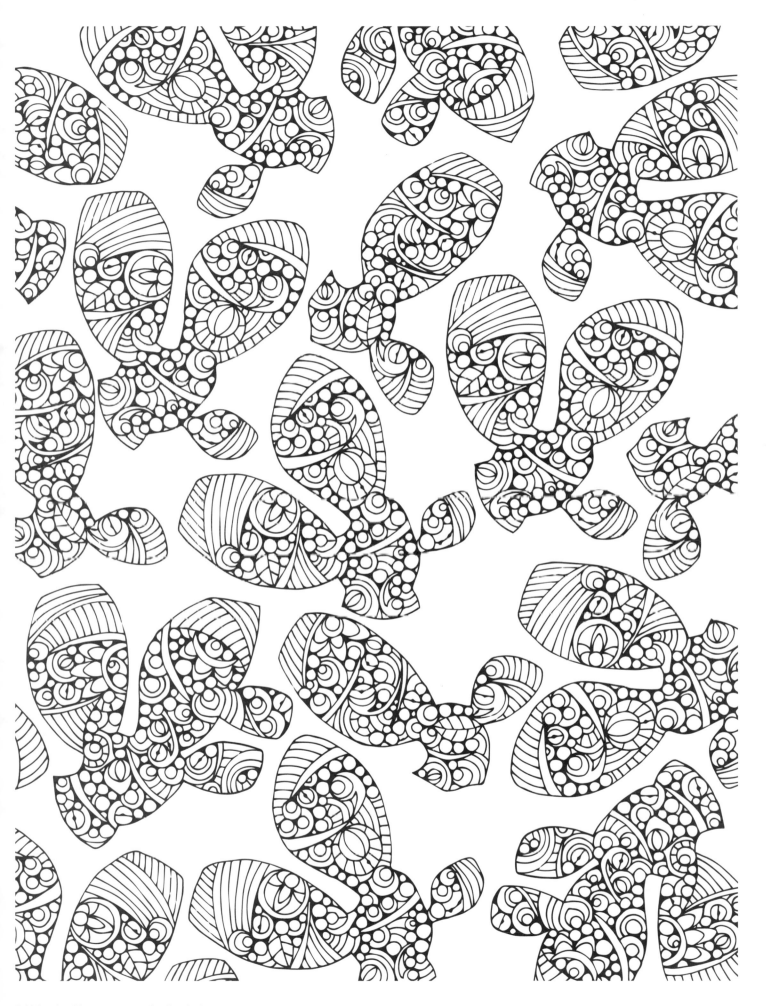

The only way to enjoy anything
in this life is to earn it first.

—Ginger Rogers

Ginger

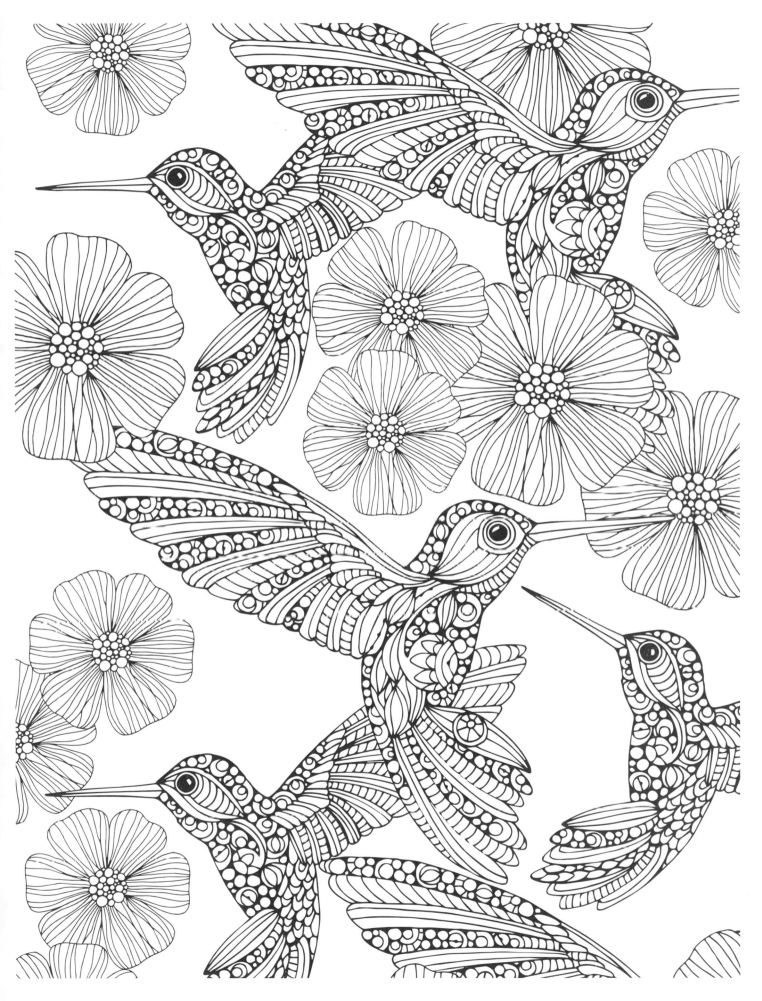

Like the hummingbird sipping nectar from
every flower, I fly joyfully through my days,
seeing beauty in everything.

—Amethyst Wyldfyre

Hummingbirds

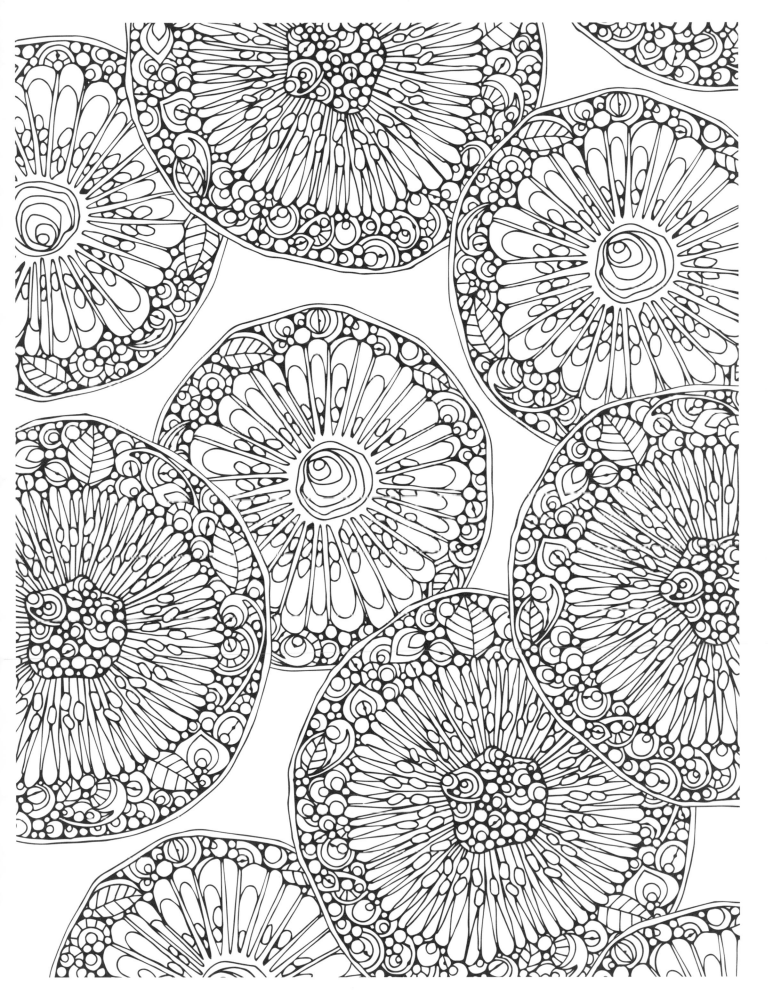

Why not go out on a limb?
That's where the fruit is.

—Unknown

Kiwi

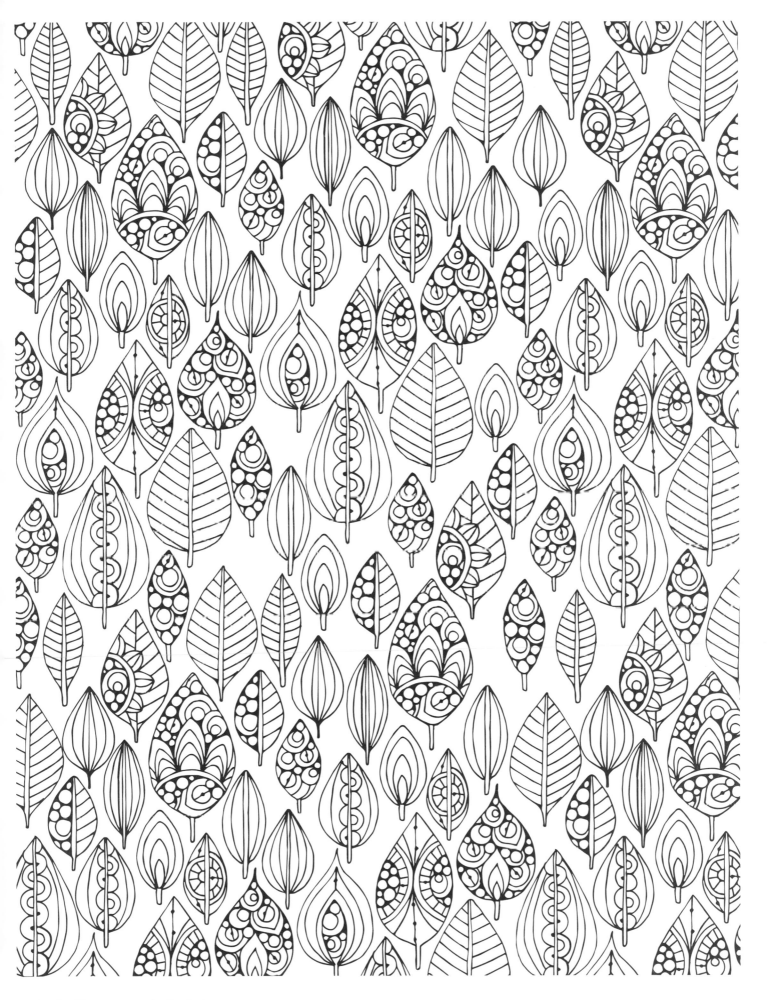

Love the trees until their leaves fall off, then encourage them to try again next year.

—Chad Sugg

Leaves

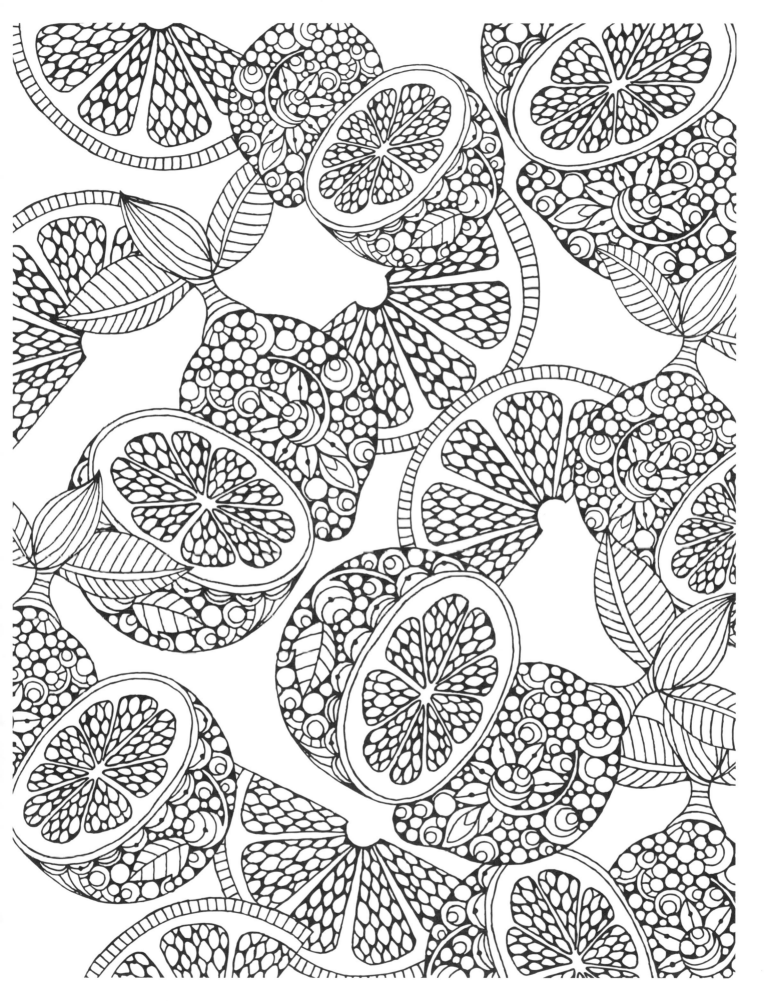

Patience is bitter, but its fruit is sweet.

—Jean Chardin

Lemons

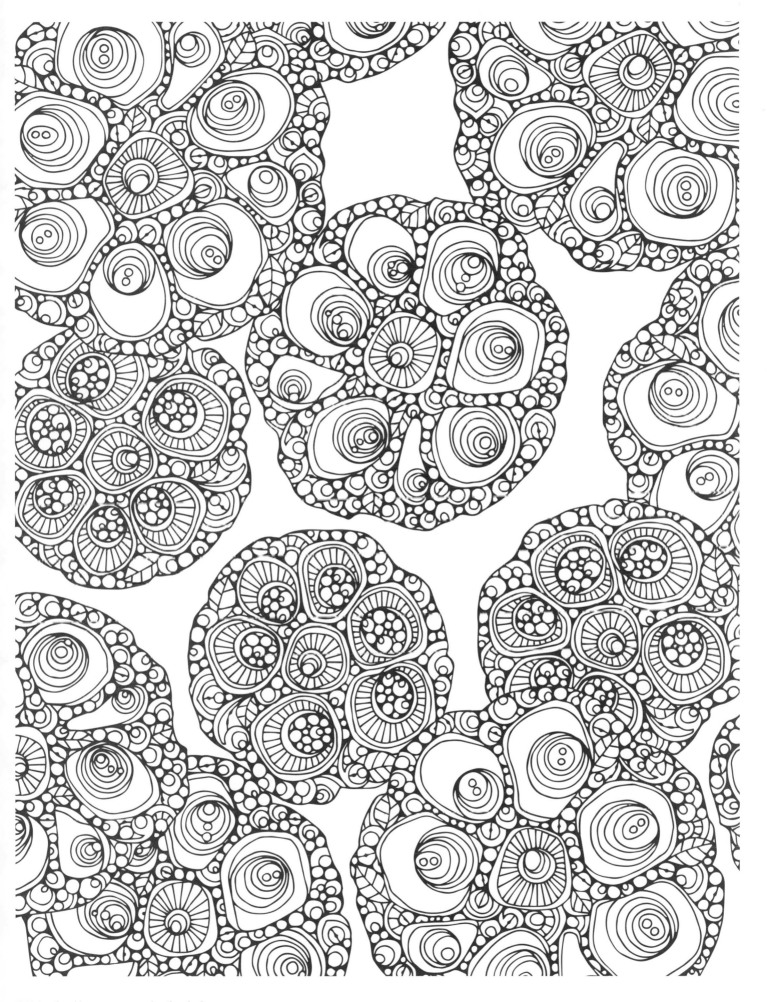

May we exist like a lotus,
At home in the muddy water.
Thus we bow to life as it is.

—Zen proverb

Lotus Seeds

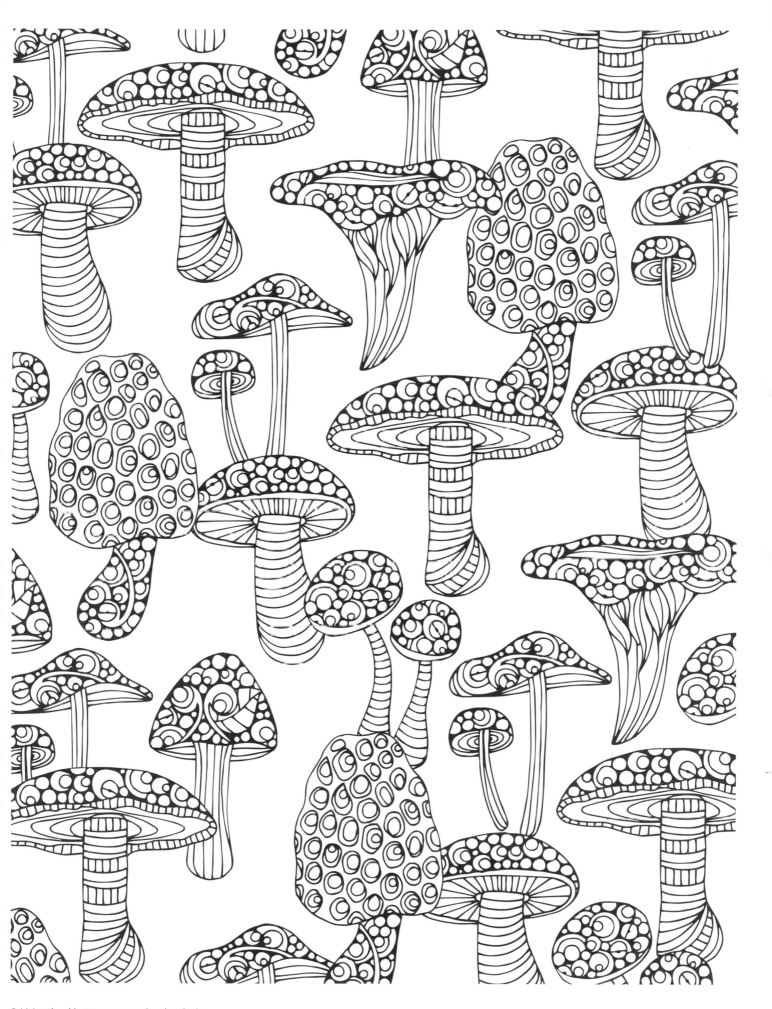

Nature alone is antique,
and the oldest art a mushroom.

—Thomas Carlyle

Mushrooms

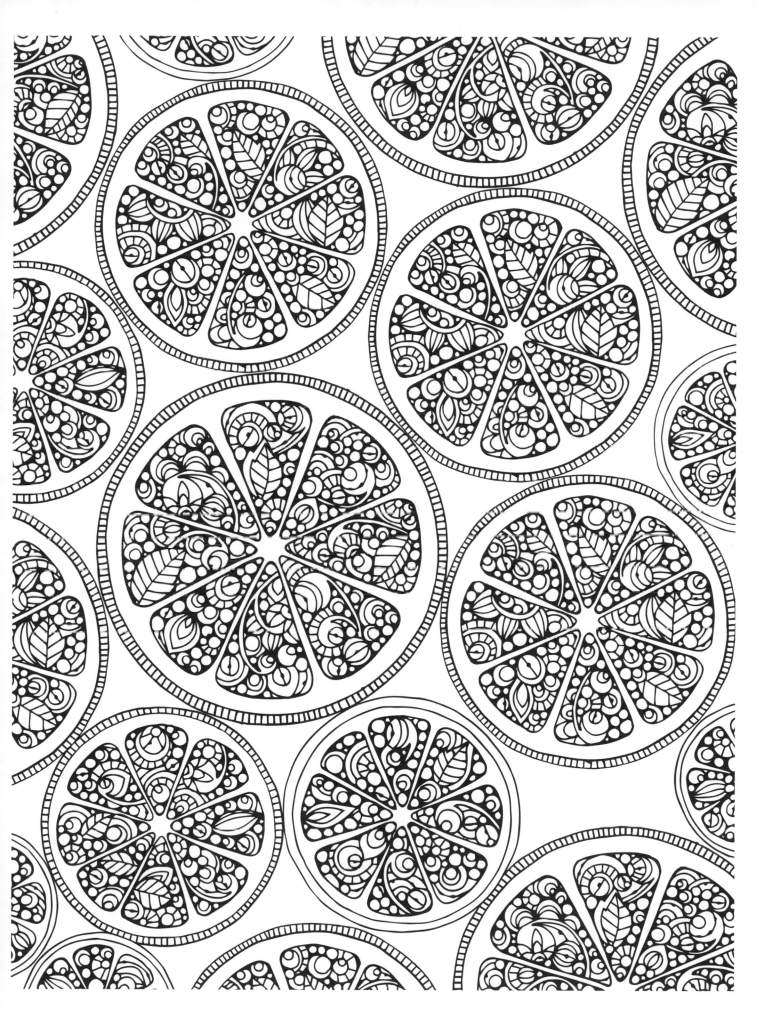

When life gives you lemons, make orange juice and leave the world wondering how you did it.

—Unknown

Oranges

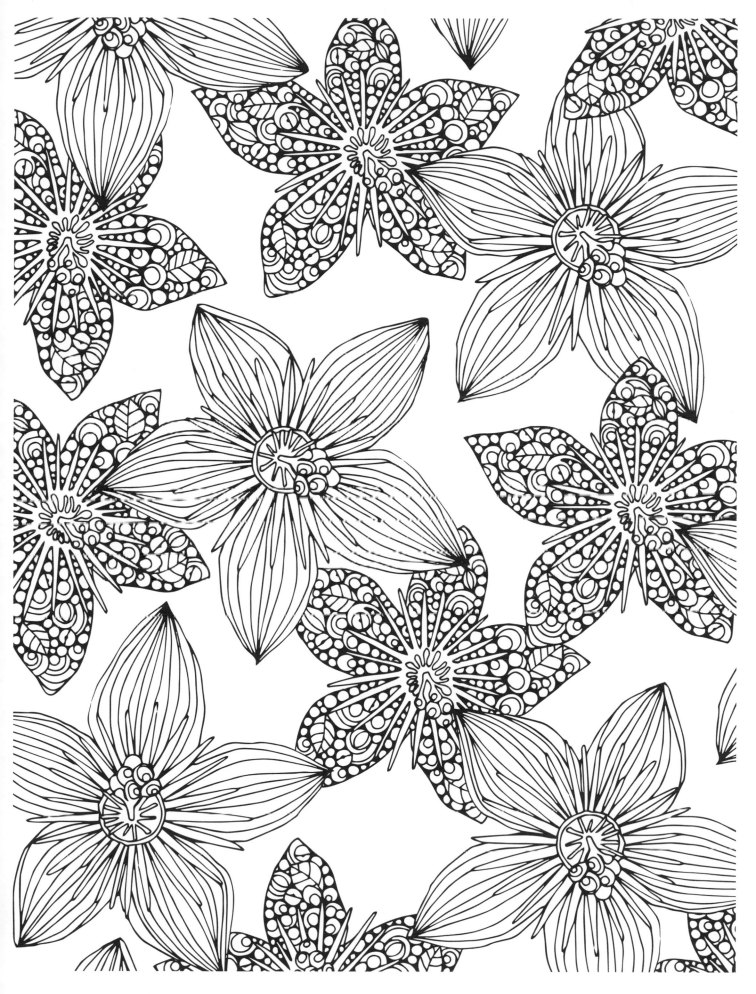

If you can't figure out your purpose, figure out your passion. For your passion will lead you right into your purpose.

—T.D. Jakes

Passion Fruit Flowers

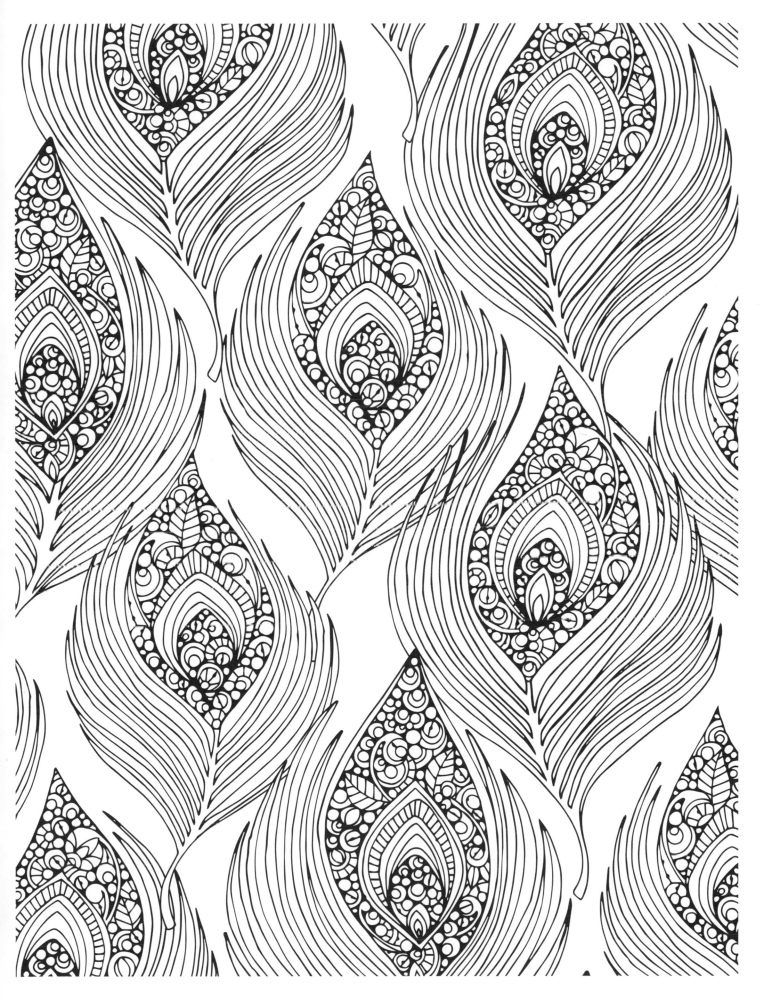

Everything you can imagine is real.

—Unknown

Peacock Feathers

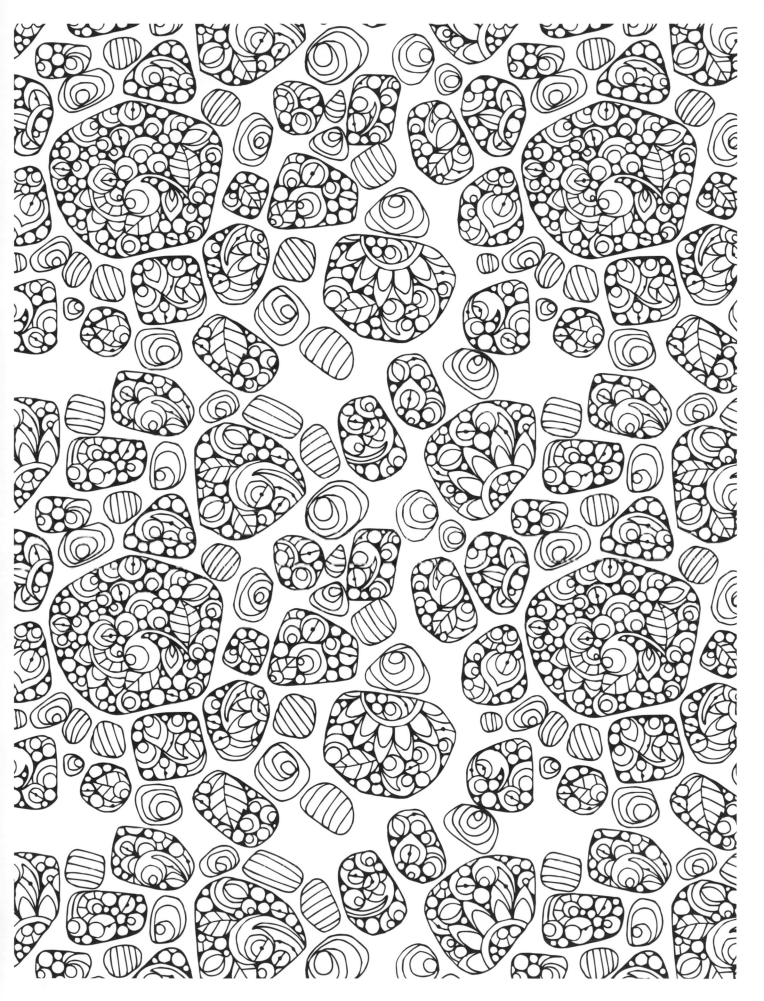

Rough diamonds may sometimes be
mistaken for worthless pebbles.

—Thomas Browne

Rocks

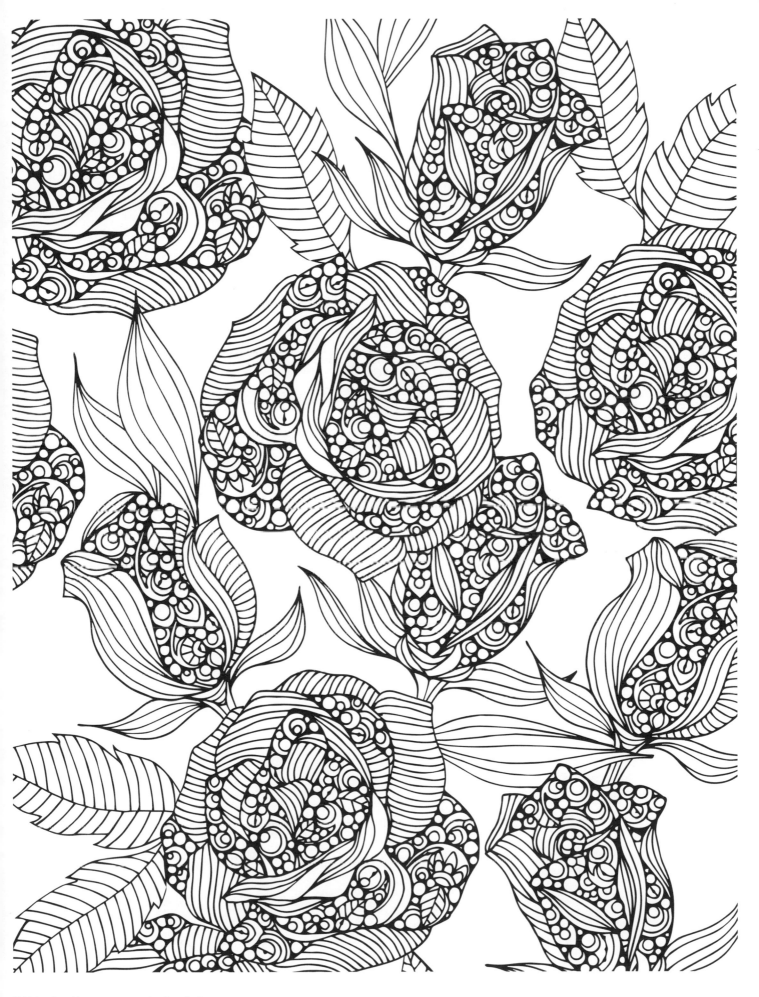

We can complain because rose
bushes have thorns, or rejoice because
thorn bushes have roses.

—Unknown

Roses

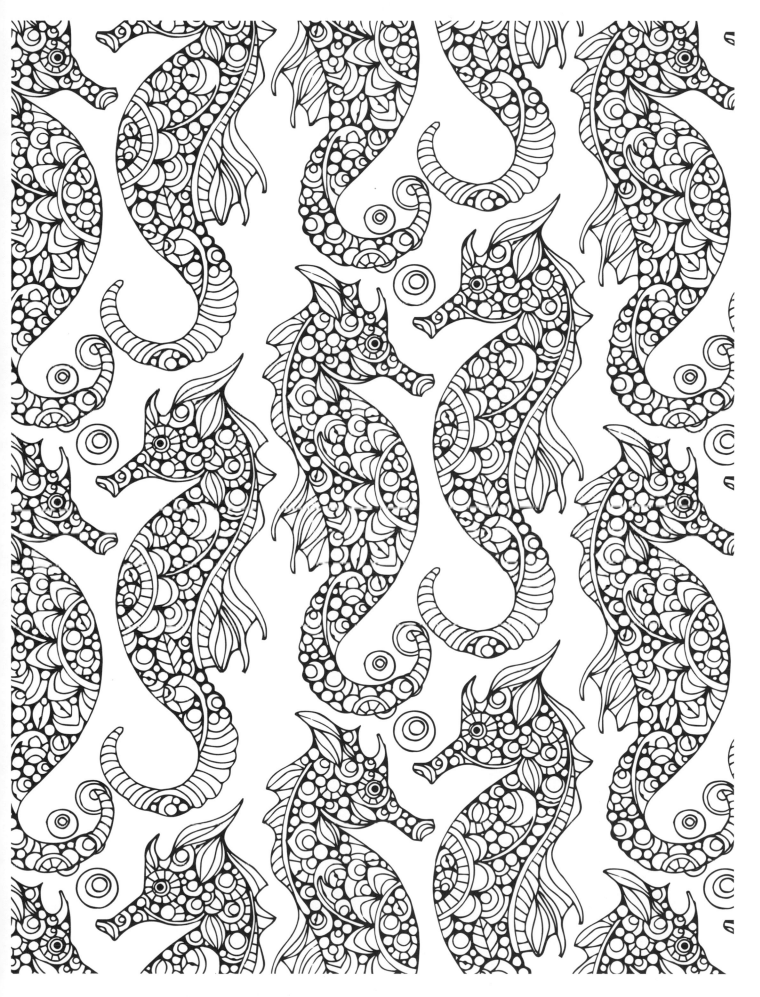

Sometimes in the waves of change
we find our true direction.

—Unknown

Seahorses

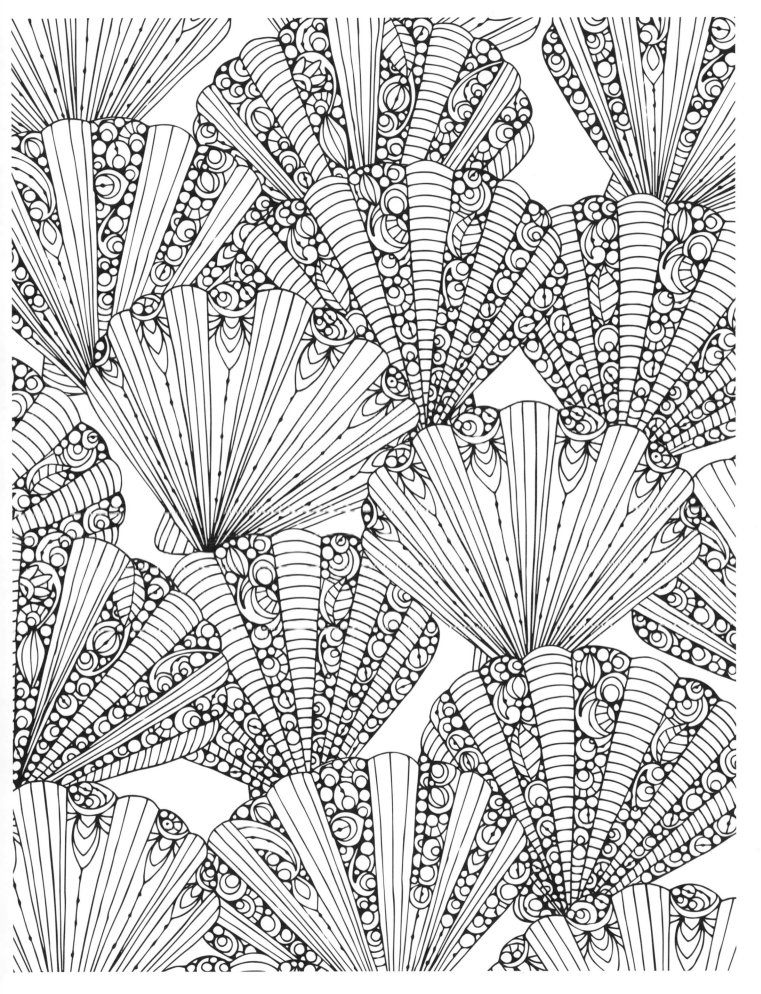

The sea, once it casts its spell,
holds one in its net of wonder forever.

—Jacques Cousteau

Seashells

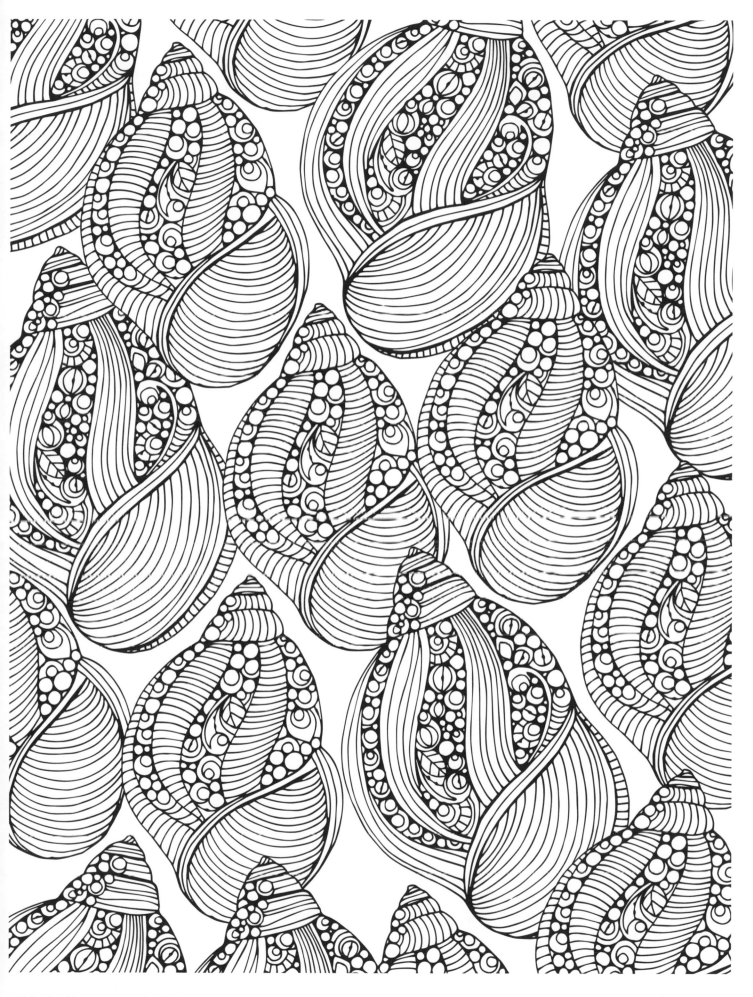

It does not matter how slowly you
go as long as you do not stop.

—Confucius

Snail Shells

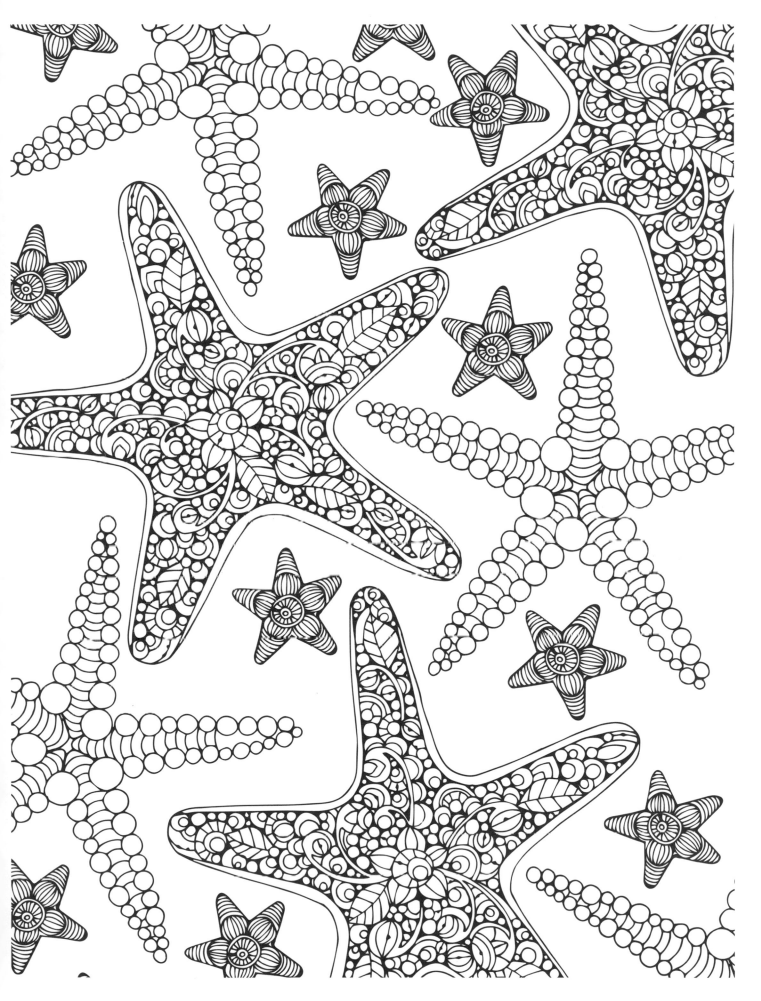

To be a star you must shine your own light, follow your own path, and don't worry about the darkness, for that is when stars shine brightest.

—Unknown

Starfish

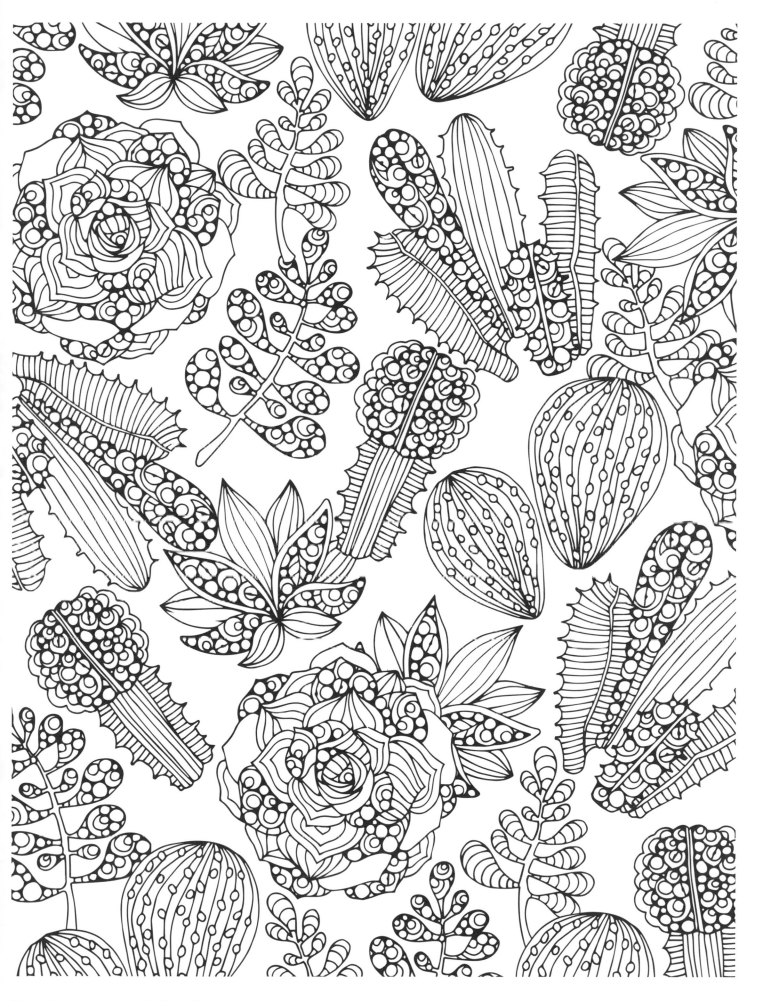

Invent your world. Surround yourself with
people, color, sounds, and work
that nourish you.

—SARK

Succulents

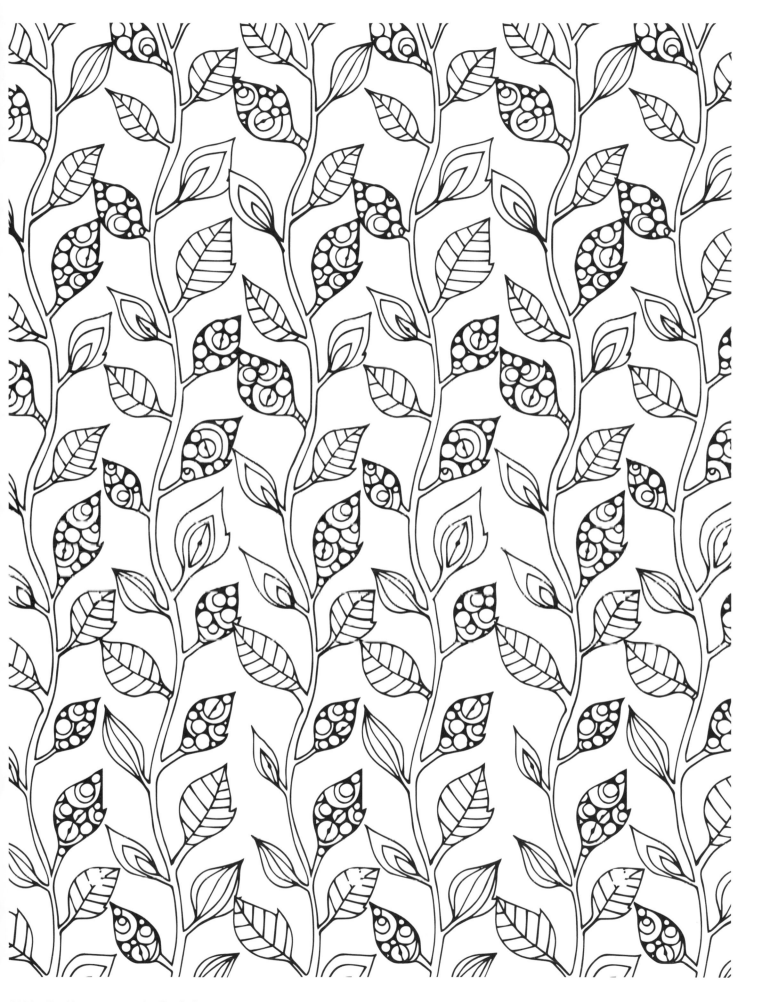

Every leaf speaks bliss to me
Fluttering from the autumn tree.

—Emily Brontë, *Fall, Leaves, Fall*

Vines

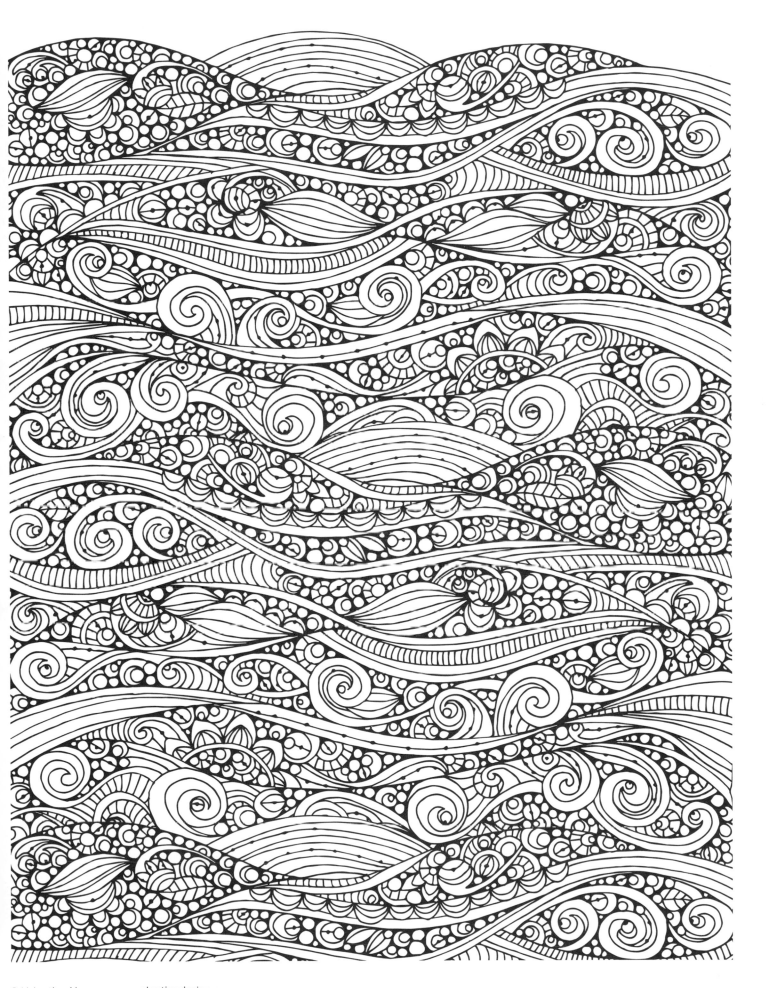

May your joys be as deep as the ocean,
your sorrows as light as its foam.

—Unknown

Water

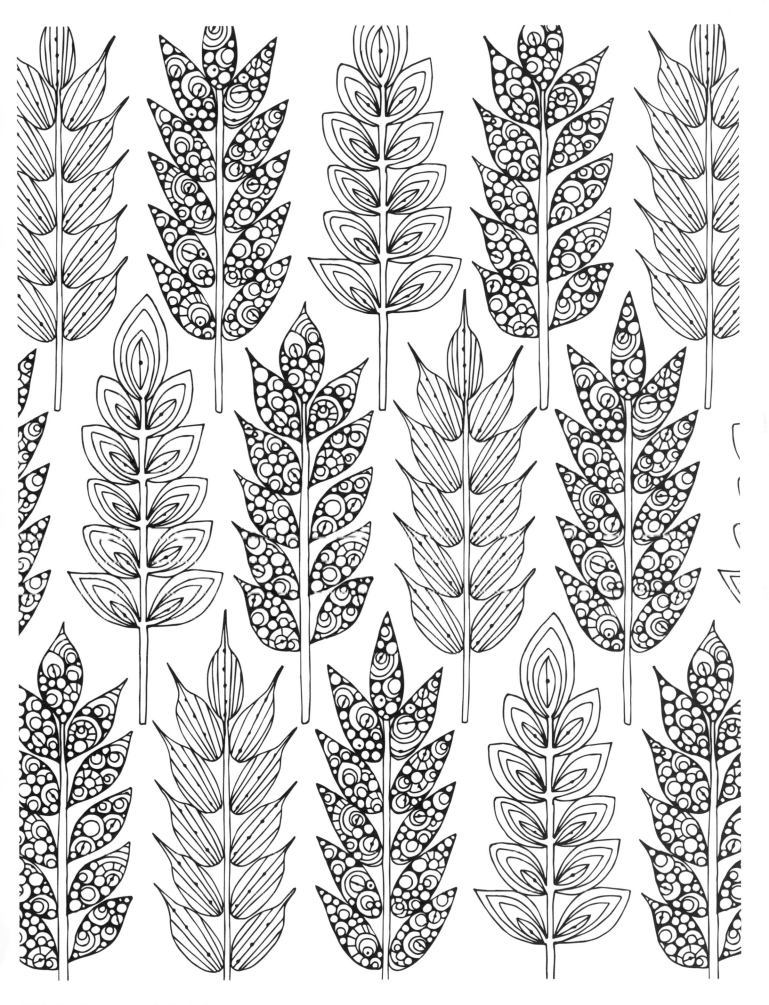

The keener the wheat the lustier the growth.

—Wendell Phillips

Wheat

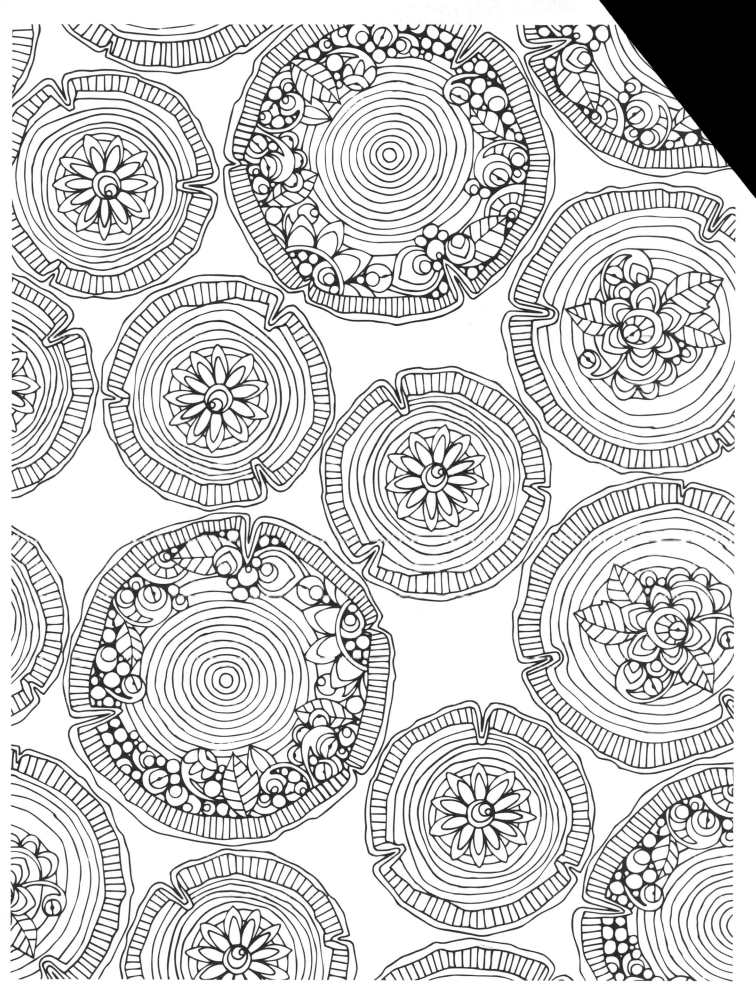

Great things are done by a series
of small things brought together.

—Vincent van Gogh

Wood